Illustratic
with Photoshop

A Designer's Notebook

Illustrations with Photoshop

BENGAL

NICOLAS **BOUVIER**

BENJAMIN **CARRÉ**

JUDITH **DARMONT**

NICOLAS **FRUCTUS**

HIPPOLYTE

JOËL **LEGARS**

ANTOINE **QUARESMA**

MARGUERITE **SAUVAGE**

TRANSLATED BY
WILLIAM **RODARMOR**

O'REILLY®

Beijing • Cambridge • Farnham • Köln • Paris • Sebastopol • Taipei • Tokyo

Illustrations with Photoshop: A Designer's Notebook
by Bengal, Nicolas Bouvier, Benjamin Carré, Judith Darmont, Nicolas Fructus, Hippolyte, Joël Legars, Antoine Quaresma, and Marguerite Sauvage

Translated by William Rodarmor

Translation © 2005 O'Reilly Media, Inc. All rights reserved.
Printed in Italy.

Published by O'Reilly Media, Inc., 1005 Gravenstein Highway North, Sebastopol, CA 95472.

Translation from the French language edition of: *Illustrations avec Photoshop - Les cahiers des Designers 07* by Bengal, N. Bouvier, B. Carré, J. Darmont, N. Fructus, Hippolyte, J. Legars, A. Quaresma, and M. Sauvage.
© 2003 Editions Eyrolles, Paris, France.

O'Reilly books may be purchased for educational, business, or sales promotional use. Online editions are also available for most titles (safari.oreilly.com). For more information, contact our corporate/institutional sales department: (800) 998-9938 or corporate@oreilly.com.

Editor:	Robert Luhn
Art Director:	Michele Wetherbee
Production Editor:	Darren Kelly
Cover Designer:	Volume Design, Inc.
Interior Designer:	Anne Kilgore
Printing History:	
December 2004:	First Edition.

The O'Reilly logo is a registered trademark of O'Reilly Media, Inc. The Designer's Notebook series designations, *Illustrations with Photoshop: A Designer's Notebook*, and related trade dress are trademarks of O'Reilly Media, Inc.

Many of the designations used by manufacturers and sellers to distinguish their products are claimed as trademarks. Where those designations appear in this book, and O'Reilly Media, Inc. was aware of a trademark claim, the designations have been printed in caps or initial caps.

While every precaution has been taken in the preparation of this book, the publisher and authors assume no responsibility for errors or omissions, or for damages resulting from the use of the information contained herein.

ISBN: 0-596-00859-7

[L]

Contents

Studio 1: Robot Lady 6
Bengal

Studio 2: Confrontation 16
Nicolas Bouvier

Studio 3: Blanche 24
Benjamin Carré

Studio 4: Let's Laugh 32
Judith Darmont

Studio 5: The High Terrace 38
Nicolas Fructus

Studio 6: London Pub 46
Hippolyte

Studio 7: Back to School 54
Joël Legars

Studio 8: Voyage to Porto 62
Antoine Quaresma

Studio 9: By the Swimming Pool 72
Marguerite Sauvage

"The robot, which had been alone for so long, didn't know that its welcoming gift wasn't suitable for the young lady..." When that sentence popped into my head, it inspired me to create this image.

Most of the illustrations I do are born this way, as tiny universes—combinations of things I have read or heard—that pop into my head and disappear a few hours later...

studio 01

BENGAL

Hardware used
- PC with 850 MHz Pentium III – 512 MB RAM
- 20 GB hard disk
- Wacom Intuos2 A5 graphic tablet
- Canon CanoScan N670 scanner

Software used
- Photoshop 5.5

Robot Lady

sketch *general idea* *final image*

This illustration embodies the classic notion of the meeting of two opposite worlds. In this case, the coldness of an imaginary robotic world and the incongruous presence of a young girl. The illustration is fairly ordinary, and the composition doesn't require much originality. The two protagonists' surroundings had to be enclosed, to preserve the intimate quality of this unexpected encounter, and to give the sense that the area around the girl is sealed off. That's why the characters are simply centered and no light source is directly visible in the image.

I didn't set any specific rules as far as color was concerned. I knew that I didn't want the picture to look shiny, but instead aged, abandoned, and lifeless. That's why the girl's skin tones are largely drained of color, and the robot and the background are rusty and rough.

"The (robot, alone for so long, didn't know that its welcoming gift wasn't suitable for the young lady..."

ILLUSTRATIONS WITH PHOTOSHOP

Stage 1

Outlining

The drawing first needs to be cleaned up and strengthened, so it doesn't disappear when the color layer, which is fairly dark, is added. The pencil sketch has a nice quality, but it might not be bold enough, and the darkest color areas could erase some lines in the final image. I save the original scanned drawing, in case of error.

I copy the base layer and clean up and remove any small imperfections due to paper, pencil, or dust from the scanner. This stage is optional: you might decide to keep these marks, which give the image a slight surface texture. But I have a specific grain in mind for the final output (I tend to use the same one in all my pictures) and I have already set several textures aside. Besides, texture shouldn't be laid down right away. It's more of a distraction at the beginning than a true graphic element, so we will deal with it later.

To deal with the imperfections, I use the Curves setting (Image➤Adjustments➤Curves). With the white eyedropper tool in the Curves dialog, I select the dirtiest part of the paper and remove the grays, which makes the surface nice and white. The eyedropper eliminates all the shades between the selected gray and pure white. Using the black eyedropper would eliminate the shades between the selected gray and pure black.

Finishing work on the sketch by strengthening the pencil lines requires only small adjustments: +5 to +10 to the Brightness/Contrast controls under Image➤Adjustments➤Brightness/Contrast.

I save the layer in Overlay mode so that it will be transparent and so all the layers beneath it in the stack can be seen. I am also careful to keep it on top of the stack during the rest of the operation.

With dust

After using the Curves tool

01 – Robot Lady

Stage 1

I sometimes like to make a drawing denser, as if it had been inked. The aim is to get a line that is truly black, but no thicker than one drawn with a pencil. There are many ways of doing this, including raising the brightness and contrast levels two or three times higher, but I prefer to do it by applying a filter to the drawing.

I copy the layer that I just cleaned up (in Overlay mode, again) then choose the Cutout filter (Filter→Artistic→Cutout). This filter can be very powerful, so it's important to set its three parameters carefully. Don't reduce the Number of Levels, or the blacks in the drawing will turn into a crude cutout; the more "levels" there are, the more shades of gray in the line will be retained. Do lower the Edge Simplicity to avoid having the line turn into a rough geometrical shape. Increase the Edge Fidelity to make sure the shape generated by Photoshop remains faithful to the drawing. Adding the previous transparent base layer of the drawing produces a bold sketch.

Seen up close, the difference is quite obvious.

This way, the drawing is (inked

in just a few seconds.

The Cutout filter's effect is somewhat related to image resolution. At a lower resolution, the geometric shape produced by the transformation can be crude. There is no problem at higher resolutions, but this requires more computer memory and yields no real benefit in terms of final output quality. Working at 200 dpi is a good compromise.

Stage 2

Color and light

I now lay down the first suggestions of color. I haven't settled on a final palette; I'm just trying a few broad brushstrokes on the surface, mainly using the Brush tool.

I want the mood of *Robot Lady* to be somewhat chilly, and look more or less monochromatic, so I start with faded, washed-out tones. It's a cautious approach, but it yields intriguing results.

At this stage I have only laid down broad brushstrokes, but I am satisfied with the main ingredients and decide to finish the image along these lines. The color seems balanced—not so saturated or lively to hurt the clarity of the image, nor so daring as to cause problems later. You can already make out a hint of shadows on the girl. The shadows are light at this point, because it's better to develop the image a little more before laying in the dark colors. There's always time later to re-saturate certain areas after I have worked on the shapes a little more, even if there are only a few of them.

I have already decided where the main light in the scene will come from and the arrangement of the characters and the tablet the robot is holding. (Don't overlook that tablet; it's one of the three masses—one of the key visual elements—in the picture.) To avoid losing too much contrast because of the brightness, I create a rough white layer and put it under the other layers, right above the Background layer (the initial drawing, which remains untouched).

If you look closely, you can see that the pencil lines are still present at this stage, and that the first brushstrokes are quick and intuitive.

01 – Robot Lady

Stage 2

After initially roughing in the main tones, darkening the background helps isolate the center of the scene. I use the occasion to further refine the colors on the robot and the girl. I already have about a dozen layers, because I add light or shadow on extra layers that I can easily find or eliminate, if I decide some details are superfluous.

Giving layers shortcut names is a very simple, practical way to keep them straight

Along the way, I retouched and refined the Color and Robot Color layers, which have the first swaths of color for the young girl and the robot, respectively. The brushstrokes have now blended together and are less obvious, and the shadows are deeper. The girl's body is almost finished. I don't want to add too much to her naked skin because it will stand out against the grainy texture of her surroundings, as we will see later.

I have a layer of dark color over the light beige of the background (created with a wide brush); a layer for the light falling on the girl's head and shoulders; and a layer for the robot's rusty joints. The layer for the girl adds more than just light: her skin tone is warmer, with a creamy, reddish color.

The choice of (colors is subtle *but very important.*

ILLUSTRATIONS WITH PHOTOSHOP

Stage 3

The Background

For the moment, the two protagonists are isolated in the center of the image. I usually draw the scenery and any surrounding objects along with the rest of a picture. But sometimes I sketch variations in my notebook, either because I'm overly cautious or because I am torn between two possibilities. I chose the background setting for this image relatively late in the process because my earlier attempts looked too "open."

After choosing and drawing the right environment, I scan it. This background isn't treated the same way as the base drawing. It will be placed in Overlay mode just beneath the two pencil drawings, Background copy and Background copy 2, which are also in Overlay mode. Then all I have to do is erase this background layer to reveal the robot and the girl. But instead of being reinforced with a Cutout filter or a similar tool, I soften the layer so it doesn't overwhelm the pencil strokes. I do this by lowering the layer's opacity.

This background sketch might have worked, but it was too open on the right, and I didn't like it.

That way, it simply shifts to the background.

01 – Robot Lady

Stage 3

For the background color, I need to isolate the overall dark color (the midnight blue layer), so I temporarily make all the other color layers invisible by clicking on the "eye" icon next to each one. The only ones I leave visible are the layers with the drawing of the characters, the drawing of the setting, and the dark color. (I keep the character layer visible so I won't color the scenery in places where it won't be seen.)

I now open a new layer where I will set the few elements of background color. I put it between the Background drawing layer and the Crate Color layer, so it will be covered by the lines in the sketches of the setting and the characters.

The background shouldn't be too bright or contrasty. It isn't the center of interest in the drawing and it shouldn't call attention to itself—the background's discretion is as essential as its presence! So the touches of color there are a little lighter, just enough to subtly highlight the shapes drawn in the background.

When I make all the layers visible to check the overall balance, I realize I have a problem. The upper left of the drawing is very heavy, and it really crushes the center of the picture. So I cast some light there. Since the light source is outside the frame and behind the girl's back, I simply illuminate the top of the image, as if light was coming from above, casting shadows through a maze of pipes somewhere above the scene.

The image is now much better balanced and airy. The equilibrium pleases me and I save it.

These highlights occur toward the bottom of the picture. I leave the upper part dark, to retain an oppressive, heavy look.

The picture's background has now come into its own.

ILLUSTRATIONS WITH PHOTOSHOP

Stage 4

Adding color

Putting in hints of color, white highlights, and adding an overall grain to the picture or specks of rust to the robot, adjusting color and saturation—these are all essential final touches. For the background texture and the metal of the robot, nothing beats an existing texture, such as a ruined wall, corroded metal, or wood. Ideally, you should photograph those materials yourself, but if not, you can find image databases on the Internet. Here I chose a flaking paint texture for the background and a porous one for the rust—the little holes make perfect flecks of rust.

The textures are applied as "effects" on the colors, so their layers are placed above all of the color layers in Overlay mode.

This mode enhances the brightness and color of the lower layers, and produces an extremely saturated rendering. To soften its impact, I reduce the opacity to less than 10%. The result has a slight sheen and a light but noticeable grain. All that remains is to erase the textures that aren't needed, such as on the girl's naked body.

Two new layers remain. The first one is easy to add: I place a new layer below the line layers and set it in Color Burn mode.

This mode literally "burns" the colors of the layers beneath it: painting on it with a light color produces a blinding, very luminous white. Look at the highlights on the girl's metal headpieces, the robot, and a few metal objects in the background.

01 – Robot Lady

Stage 4

It won't influence the background, so it is placed under the background color layer.

The final layer is an adjustment layer, designed to modify the color data in the lower layers. The layer type—Hue/Saturation—I create by selecting Layer ➤ New Adjustment Layer ➤ Hue/Saturation. By enhancing the girl's hair and shoulders, it adds life to the center of the picture, warmth in the midst of cold.

The purpose of this layer is to saturate the girl's skin color and the red of her hair. The warm yellow and red tones make quite an impact.

Dull...

...or saturated?

The piece is now finished. This image is typical of my little world, and yet at the same time it is very specific, which is what makes it so distinctive. ■

15

SPARTH
2002

This is an example of a digital image created without an initial paper sketch, because I did most of the work with Photoshop's Airbrush tool. Thanks to the many effects that layers afford, an artist can skip a preparatory sketch, and try any number of things.

The painting took me about fifteen hours of work, which most people would agree isn't much time. One of the main advantages of creating images digitally is the possibility of doing good work quickly.

studio 02

NICOLAS BOUVIER

Hardware used
- PC with 600 MHz Pentium III
- 256 MB RAM
- 14 GB hard disk
- Wacom Intuos2 A5 and A6 graphic tablets

Software used
- Photoshop 5.5

Confrontation

Sketch — *Composition* — *Final image*

The illustration shows a brief confrontation, in which a military patrol faces off against a potential enemy.

This image wasn't a commission, but it's typical of the kind of work that I do for video games. The difference was that I was able to spend more time exploring some techniques I usually don't have the leisure to experiment with. Although it wasn't easy, I skipped drawing on paper to work directly in Photoshop, concentrating only on shapes and masses—a more pictorial approach, in some ways. I have to admit that I've come to prefer this approach. It gives me instant satisfaction, since I can see a concept take shape in a few minutes, and in color.

I often get my (ideas *from science fiction movies.*

Stage 1

Perspective

I decide to show a forge at the bottom of a subterranean chamber with neither roof nor floor, but with bridges connecting the two sides. Using the Airbrush tool, I start by creating a very rudimentary sketch of the setting as seen from a high-angle perspective.

I will use the airbrush tool for the entire illustration, maintaining a constant 25% pressure on the graphics tablet.

For the moment, the only visible element is the main bridge. I paint it a very dark color, since the primary light will be coming from below, from the bottom of the pit. I usually use a white background when beginning an illustration so the image retains a lot of openness. You don't want to block the light at the outset, which often happens when you start with a black or colored background.

Before starting a digital painting, you should have a pretty clear idea of its composition. It's impossible to decide everything ahead of time, of course, but if you set out blindly, the image will suffer, because constantly changing your mind will detract from the final composition.

02 – Confrontation

Stage 2

Composition

Once the perspective is established, I finish the sketch. I leave color aside for the time being, because it's easier to establish a graphic and visual balance using black and white. I add a few more transverse bridges, which give the image more perspective and rhythm, an effect accentuated by their repetition.

Adding similar objects within a dramatic (*perspective is a useful way to add depth to a scene or landscape.*

I decide to include a military spacecraft in the foreground, drawing its shape very roughly for now. By choosing my particular vantage point, I am inviting the reader to enter the action, to feel the effect of gravity and empty space. The high-angle view reinforces the sense of danger and clearly shows the abyss yawning below the characters in the foreground.

Next, I focus on the background. I use orange to define the glowing lower chamber, while preserving a certain amount of transparency. This is where the Airbrush tool comes into its own. Unlike a regular paintbrush, the Airbrush lets you color parts of an image with light colors, without covering the white in areas that are still untouched. I then increase the image's overall contrast by adding a warm gray to the walls.

To make the background really glow, I superimpose an extra layer created in Color Dodge mode to drastically rework the lower depths of the chamber. I even let the light wash out some of the details on the walls.

Throughout the process, my left hand is ready to press the Shift-I Eyedropper tool shortcut. It's very useful for quickly mixing colors that are already present in the image.

Stage 3

Background

When I am satisfied with the illustration's overall structure, I can confidently start working on the background. I notice that the chamber depths aren't as intensely colored as I would like, so I increase the image saturation by +40. Having those warm hues available will make it easier for me to choose the base colors later, when I refine the background.

I first concentrate on the most distant bridges, adding details using presets between 3 and 10 pixels. With the Eyedropper, I sample only neighboring colors and avoid choosing cold ones. From this distance, the subterranean furnace should look like it's burning. I remember that the lower parts of the bridges will be lit by intense light from below, which will allow me to add a lot of details by using only light.

Still, I don't want the more distant bridges to stand out too much because of excessive shadows; otherwise, I would lose the background's characteristic hazy appearance. So I make the shadows progressively less intense as you go deeper in the image.

I add tiny details under the different bridges. It's important to always choose very light colors so you don't darken this part of the scenery, since the brightest parts of this picture are the deepest ones. Because of their positions, the bridges don't receive any light at all on their upper sides, which allows me to accentuate the guardrail in the foreground.

In order to add detail around the guardrails, I strengthen the original perspective using the Line tool with the thickness set between 4 and 8 pixels.

To create an interesting balance, it's essential to insert the cold colors that are missing from the picture. I mostly take them from the areas that light isn't reaching—such as the tops of the bridges—where I start applying touches of blue and purple..

02 – *Confrontation*

S t a g e **3**

Foreground

To help separate the foreground from the background, it's time to work on the spacecraft, using cool colors with a range of gray hues. Choosing cold, bluish colors will help the vessel stand out, and make it look more convincing. After roughly determining the runabout's outlines, I focus on giving shape to the right side of the ship by lighting it with an imaginary light source located outside of the illustration. This out-of-frame light will be very useful when I turn to the foreground action scene.

To make the foreground more vivid, I need to define all of the essential details. Unlike with a landscape, it's always a good idea to leave a foreground with some finished, specific elements to hold the viewer's eye.

The spacecraft's forward cockpit will be occupied by two pilots, so that area must give off a feeling of life and activity. I accentuate the light there by adding a layer in Color Dodge mode.

I finish by more precisely defining the outline of the ship. Still using the Airbrush, I go over the contours of the vessel and its crew. I then create a second layer in Color Dodge mode, where I paint all of the outlines of the vessel in a series of orange highlights. The contrast between the vessel and the background is now complete.

21

ILLUSTRATIONS WITH PHOTOSHOP

Stage 4

Setting and atmosphere

In order to add some graininess to the image, I superimpose a very saturated purple texture on my illustration. This is useful for two reasons: it helps balance the picture's warm and cool colors, and it adds roughness and graininess that were missing in the original image.

The purple texture will be merged in Overlay mode. I keep it under 35% opacity so it won't obscure or block the image.

I notice that the darkest areas of the upper part of the picture still lack definition and richness. I solve the problem by creating some additional light sources to brighten these areas. I concentrate on painting in the details precisely. To give the illustration a luminous rhythm, I also add some color in the distant planes just above each bridge. These light-blue touches —a color complementary to orange—will stand out visually among all of the "volcanic" colors.

I now have the task of giving a narrative meaning to the picture by adding some characters on the bridges. The best way to create these shapes is to start with almost pure black, then add corresponding light accents. This requires care, since each character is lit by two sources: a secondary bluish color coming from behind them and an orange color on their faces and shoulders. When the characters on the bridge still don't stand out enough, I add a fairly bright bluish light coming from the walls. ∎

The image is still somewhat lacking in sharp outlines. To eliminate overly visible blurs and increase contrast, I use the Watercolor filter (Filter→Artistic→Watercolor). First, however, I duplicate my principal layer so I can apply the filter to the copy. Thanks to the Eraser tool, I can now erase any area in the second copy where the filter's effect isn't needed, in particular, the haziest part in the depths of the chamber. Otherwise the filter might strengthen the image too much, to the detriment of the final result.

22

02 – Confrontation

Stage 5

Finishing touches

It's now time for the last touches. I change elements here and there that don't meet my aesthetic standards. The shapes of some of the soldiers in the middle distance don't quite satisfy me, for example. Using a small preset, I better define these characters' body shapes. I try not to go overboard, because what I most want to convey is a sense of nervous energy. Spending too much time on certain details can wind up hurting the picture.

When I show my nearly finished picture around, several people suggest that I rework the foreground character on the left. The two male figures are doing the same thing: they both have weapons in their hands, ready to shoot in a crossfire, which seems visually repetitive. I change one soldier's position so he is holding a larger weapon but no longer pointing it toward the bridges, like his partner.

In finishing up, I feel the image needs a little more energy, particularly in the shadows, so I color it more strongly. Using the Image ➔ Adjustments ➔ Color Balance dialog, I add +10 of blue to the dark colors, and +10 of yellow to the light ones.

This is the last adjustment. I am now satisfied with the final result. ■

I better (define these characters' body shapes
without going overboard, because what I most want is to convey a sense of nervous energy.

I wanted to use a mixture of genres to portray a futuristic world, but one composed of aging architectural elements in a damp, run-down setting. I know this sounds like a cliché, something with a strong sense of déjà vu. But we shouldn't always be afraid of clichés. When recast and rethought, they can become quite original.

studio 03

BENJAMIN CARRÉ

Hardware used
- PC with 450 MHz Pentium II
- 128 MB RAM
- 20 GB hard disk
- Wacom Intuos2 A6 graphic tablet
- Epson PC 3000z digital camera equipment

Software used
- Photoshop 5

Blanche

Snapshot Composition Final image

This image is the first panel of the story "Blanche," which was created for volume 2 of the *Vampire* graphic novel series from éditions Carabas. This volume, called *Vampires²*, consists of several short stories written by different authors. "Blanche" is just seven pages long. When you have so few pages in which to express yourself—and it's also your first experience illustrating a graphic novel—you really want to give it your all, expressing as many things as possible in the fewest pages. It becomes a sort of artistic calling card.

Given that kind of pressure, my goal was to set the scene as efficiently as possible, which is why the picture has such an "illustration" look, considering it's in a comic book. For this image I was directly influenced by such movies as *Blade Runner*, *The City of Lost Children,* and *Dark City.*

In short, you have a lot to (prove— to your future readers, to your editors, and especially to yourself.

ILLUSTRATIONS WITH PHOTOSHOP

Stage 1

Photographs

Most of the photographs used in this image weren't taken specifically for this graphic novel. I often work with photos, especially of cityscapes, so I have gotten into the habit of always carrying a digital camera. Industrial areas and abandoned buildings are part of my favorite walks, and I have built up a big database of landscapes I have encountered in my wanderings.

The only photograph I took especially for this piece is the one that serves as the illustration's background: a concrete wall showing traces of glue and fabric that had been torn away. For me, it's very important never to begin a picture with a white background. The small irregularities and texture of a real surface stimulate my imagination and help me get started more easily.

It's a (magical location
at once Gothic and industrial.

This photo serves as the background for the illustration

The main photograph was taken at the Grands Moulins de Pantin—the century-old flour mills in Pantin, a suburb northeast of Paris. It's a magical location, at once Gothic and industrial. The mills are now shuttered and I've never been allowed to take photographs inside, for reasons of safety and insurance. But a walk around the mills is well worth the trip. The scene that caught my eye was the cantilevered structure jutting out of the side of a building, which wound up being the central element in the illustration.

Stage 2

The Paste-up

I now paste my photograph from Pantin onto the concrete wall that is serving as the "sky" for my picture, and frame it horizontally. I erase the parts that don't interest me, which allows the background to show through.

This is a photograph that *stresses the horizontal in a format that is itself horizontal.*

When you use different photographic sources, their colors and brightness often don't blend very well. The solution is in Photoshop's Image→Adjustments menu, where you find the Curves, Color Balance, Brightness/Contrast, and Hue/Saturation tools. By fiddling with their parameters a little you can quickly learn how to harmonize two images.

At this point, I have mixed feelings. On the one hand, I'm pleased with myself—I didn't take this picture for nothing, and with a little luck, I'll be able to create an unusual illustration. On the other hand, I'm a little dubious. I had originally planned to show a city with tall buildings that reinforced a feeling of strong verticality. And yet this photograph stresses the horizontal, in a format that is itself horizontal. I better be sure to find that verticality somewhere else. ■

ILLUSTRATIONS WITH PHOTOSHOP

Stage 3

Composing the picture

I then create a new layer so I can work on the background.

I find it very important to create a new layer for each operation. This allows me to draw more freely, without fear of spoiling what I've already achieved. Working this way, I'm more daring, I try things, and I leave myself open to chance and accidents—which I feel can only lead to pleasant surprises.

I **recompose** my image *to stress verticality, by drawing some tall buildings in the distance.*

Using the Airbrush (and black), I recompose my image to stress verticality, by drawing some tall buildings in the distance. But in spite of all the skill and goodwill I apply to my Wacom drawing pad, the resulting shapes are soft and spineless —exactly what a skyscraper is not.

I decide to refine the shapes by using the Polygonal Lasso tool and the backspace key. I trim the outside edges of my black blobs to make them look a little more like buildings of the future.

Finally, I apply a very slight Gaussian Blur filter to the entire layer, to give a feeling of unity to the outlines and a sense of depth.

28

Stage 4

Details in the scene

While the quality of an illustration's composition is the key to its success, the little details shouldn't be overlooked. They make a picture more believable, more real. Besides, this stage is by far the most fun for the illustrator and the most appealing to the viewer, so it would be a pity to pass it up.

The tall buildings in the background also need façades, but I don't have any photographs of walls that big! I could draw them directly, of course, but that might clash with the image's very photographic overall look. So I select a tiny piece of façade and copy and paste it repeatedly, wallpapering as much of the surface as I need. I'm careful to brighten some windows in the process, to suggest the lights of the city.

A few more details will add life to this little world: a few hanging cables (drawn with the Airbrush), some catwalks (a photograph of a crane turned horizontally to suggest scaffolding), and a red light (from a photo also taken in Pantin), which supplies a touch of color.

I start work on the main cantilevered structure and decide to make it a little dirtier. To do this I create a new layer, open the Layers palette, open the pull-down menu, and change its properties to Hard Light, and add some stains to it.

I also change the windows on the structure, which seemed a little dull in the original photograph. I cut them out and paste in some windows taken from a glass building shot at sunset. I also make one of the windows completely white, so it appears to reflect sunlight right into your eye.

I then move on to the buildings' façades. Directly behind the cantilevered structure is a section of wall that I don't much like. I replace it with the façade from another building taken from my database of urban photographs.

I tend to conceive of illustrations with ranges of fairly desaturated colors, to produce a dull, washed-out look. So adding a spot of bright color like a red light, no matter how small, gives the picture presence and draws the viewer's attention to a specific place—in this case, the person standing on the cables.

You can already start to see what the picture will look like. But for the moment, it looks more like a clumsy photo collage than a science-fiction illustration. There's no need to panic; this is normal. Now it's time to work on the atmosphere.

Stage 5

Atmosphere

Photoshop's atmospheric effects will greatly help me to enrich the image's mood.

The second method, and the one I chose here, avoids flattening the image. I need only create a new layer on top of all the others, which I name layer A and I don't touch for the time being. I then create a copy of the background layer, which I label layer B. I now slip layer B above layer A (the city should no longer be visible since it has now disappeared under the copy of the background). In the Layer menu, I choose Group with Previous (Ctrl-G). The city should reappear, because layer B is now invisible. I then select layer A (which I haven't done anything to yet), and, using the Airbrush, draw whorls of smoke in white. It's like magic! What I am drawing doesn't show up as white, but instead takes the texture of layer B, as if the strokes of the Airbrush were making visible that which was invisible—which, in fact, is what it's doing. This method is more complicated, but it gives me more control over the process of drawing the smoke, and it leaves the layers intact.

I get (beautiful swirls of smoke *that are more or less opaque, depending on how hard the eraser strokes are.*

As I flip through my mental megalopolis clichés à la *Blade Runner*, I realize I need some heavy, dense patches of smoke. They will both enrich my world and help me hide the awkward seams that still exist in the photomontage.

There are several ways to create smoky clouds; here are two of them.

The first method is to merge all of the layers except the first (the one that serves as a background). This leaves me with a background layer and a city layer. All I have to do is make some swirling eraser strokes on the city layer, which lets the background layer shine through. The effect is terrific: I get beautiful swirls of smoke that are more or less opaque, depending on how firm the eraser strokes are. This method is simple and quick but it has a drawback: I have to flatten my layers, which can lead to problems if I want to retouch the composition later.

I'm delighted by the idea of re-using the background imagery to draw the swirls of smoke. It's such an obvious and efficient trick. It also appeals to me because it nicely illustrates the seat-of-the-pants approach I took in creating this picture—or maybe because it flatters my ego to think I'm being inventive.

03 – Blanche

Stage 6

The final touches

Smoke is all well and good, but it isn't enough to create the entire mood I had in mind before I started the illustration. The atmosphere still isn't damp enough, and it doesn't look polluted enough. For this, I'm going to use a photograph . . . of nothing! In this case, it's one of those blank pictures that came back from the photo finisher stamped, "No charge." It is sort of beige and fuzzy, and has incredible grain—in other words, the ideal photograph for creating the atmosphere I want.

My picture is almost finished, but it's still a little dark, so I use a simple and efficient trick to fix that. I need only create a new layer (yes, another layer!), set its parameters on Burn, and apply very light white touches with the Airbrush where I want the light to fall. You have to be careful; these touches must be very light or you'll easily burn the image. This trick brightens my picture, but it also plays an important role in the composition of the illustration. Used correctly, it even allows me to underscore the feeling of verticality that I so desired in the beginning. Voilà!

"No-charge" photo

I slip it to the top of my pile of layers, set its parameters to Color Burn and its opacity to 66%.

I apply very white (light) touches with the Airbrush where I want the light to fall.

Adding light to the image

All that's left to do is to take the Airbrush and draw the little vampire standing on his cable. This somewhat small image in the first panel of the graphic novel connects to the enlarged shot of the vampire in the second panel—a panel about which there is much more to tell. But that's another story. ■

31

The point of departure for this digital painting was the phrase, "Let's laugh." I said to myself, "Since it's serious, let's laugh!" Since life is a continual struggle, let's laugh, let's be detached. I wanted to give my character a serious attitude and expression that would be out of sync with the painting's title.

studio 04

JUDITH DARMONT

Let's Laugh

Hardware used
- Power Mac G4, 1GHz
- 768 MB RAM
- Epson Perfection 1250 scanner
- Wacom Intuos2 A5 graphic tablet
- Epson 1520 printer

Software used
- Photoshop 7
- ArtMatic Pro 3

Pencil sketch *Colored in*

Final image

I have always painted portraits of women. A woman's questioning gaze makes a connection with the viewer. She plays on her duality as both actor and spectator. I produced this digital painting using background, textures, and colors to convey my subject's personality. The painting was printed on a 39 x 32 in. (100 x 80 cm.) canvas.

I often use (geometric shapes, type, and symbols *of all kinds to represent my subject's feelings or thoughts.*

Illustrations with Photoshop

Stage 1

Sketch and Tools

For all of my digital paintings I start with a blank screen and sketch my character right on the tablet. I try to imagine her story, her surroundings. Color comes next: her face, her look especially; that's what I work on the most. I try to find the warmest emotion using this somewhat cold tool that is the computer. After that, I work on the body, fabrics, and colors, and then the background, which in some way represents the character's inner world. Textures, shadows, and light—once all these are laid out, I can start refining each detail and give life to the portrait.

In general, my digital paintings are printed on fabric or canvas. The prints measure at least 24 x 32 in. (60 x 80 cm.). Because of the size of the files and the time required for rasterizing and printing, I work at 200 dpi resolution. When creating my document in Photoshop, I work with a reduced image, usually 25% of the output size.

I always start with the Brush tool and a white background. I choose a line thickness of about 3 pixels. The Wacom pen allows me to adjust the line's transparency and intensity by controlling the pressure while I sketch the character. My hand experiences the same sense of rightness and precision as when I use pencil and paper.

One thing I really like about Photoshop is its ability to generate layers. They're perfect for preserving the different stages of my digital painting. They let me store the painting's entire evolution, and resurrect its genesis at any moment, starting from the very first sketch.

I can resurrect the **(picture's** *genesis at any moment, starting from the very first sketch.*

Photoshop is a very "open" application. I like its neutrality and the interchangeability of its tools. The eraser can become a paintbrush, and vice versa. Because of this, you can create an entire picture using a single tool, simply by modifying its parameters.

04 – Let's Laugh

Stage 2

Expression and the application of colors

The first thing I work on is my subject's expression. I establish her character. This defines the picture's setting and mood, so it is the first part of the portrait to be colored. As a general rule I choose three or four colors that I want to interrelate. I then use Photoshop's Color Picker. This way, I can not only visualize the colors but also regulate their respective percentages in the different modes (RGB, CMYK, etc.), and see the color values.

I like to begin with flat coats of color for the background and clothes. This allows me to lay down a first "basic" layer to establish the setting, then place my character in space. This helps anchor the painting's balance. I use either the Brush or the Airbrush tool for this, depending on the look I want. The Brush is practical for flat colors; the Airbrush creates a light, gauzy look.

I use the Smudge tool to (stretch the rendering
on the right side of her face.
This suggests movement.

After laying down the background I return to the character, who remains the central element of my digital painting, and I finish her face. I use the Blur tool to smooth her features and the Smudge tool to stretch the rendering on the right side of her face. This suggests movement.

In the course of building my image I keep all of the layers. When I leafed through them later, I realized just how much the face evolved before attaining its definitive expression. There's such a wealth of material here that I could create other characters from this cache of variations.

35

Illustrations with Photoshop

Stage 3

Surface characteristics and texture

Once in a while, I find scraps of images on the Internet, often in black and white. I enlarge them, and often use them to help create the densities and textures that will be merged into the final image.

I open them in Photoshop and slide each picture toward the main image using the Move tool, which generates a new layer.

Next, I open ArtMatic from U&I Software (*www.artmatic.com*), a very powerful fractal-based digital imaging tool that's perfect for generating complex textures and backgrounds. All of the colors are produced from algorithms and the resulting surfaces are vibrant and alive. When I find the right texture, I save it in PICT format.

I use ArtMatic a lot—the interface is very intuitive and easy to master. It's a superb tool for both textures and colors.

I return to Photoshop and insert the new texture into my file. For now, I simply overlay it roughly onto the table that my character is leaning against. I'll work on the details only at the last stage, where I'll bring the table and this texture together. I check to see that my image is still balanced when it comes to colors and surface characteristics. ■

Color Burn mode

I then put these texture layers in the background of my painting. From the Layers palette, I apply 60% opacity and Color Burn mode. To blend these surface characteristics, I clean them with the Eraser and apply them to my character.

04 – Let's Laugh

Stage 4

Adding light

When building an image, one moment I love is adding light. For this I use a trick: I create a new layer in Normal mode, which I put above all the others. This layer is black, with an opacity set to 80%, so my image almost completely disappears (though I can still make out the painting).

Using the Eraser with the Airbrush setting, I gradually uncover the image, erasing the black layer little by little.

This is really the magical stage in creating a picture. The character suddenly takes on a great deal of intensity and light. I brighten the interesting parts of the painting until I feel it's time to stop.

I reveal the image very carefully, using the Wacom tablet to shape the intensity of the erasing and the way the light falls.

As my creation comes to fruition, time is suspended. Creating the character's look and bringing the image to life have been the two decisive moments of this digital painting.

37

When you use digital methods, you can rework an image practically forever, which is almost impossible in traditional art. But that's also electronic art's biggest pitfall: it's hard to know when to stop. You can always fiddle with the details some more, change the colors, and surprise yourself with new discoveries. When in doubt, stop for at least twenty-four hours. Then reopen your illustrations and make up your mind. The image with the most impact will usually be obvious.

studio 05

NICOLAS FRUCTUS

The High Terrace

Hardware used
- Power Mac G3 350 MHz
- 512 MB RAM
- 40 GB hard disk
- Agfa Argus 1200 scanner

Software used
- Photoshop 4

Sketch — *Base colors* — *Final image*

My task was to create illustrations for nine chapters of a special issue of *Casus Belli* magazine devoted to a mythical city called Laelith. Each illustration was supposed to show the atmosphere of the neighborhood being described.

The image presented here is of The High Terrace, a rich and colorful environment where Laelith's leading citizens are found. The rocky spires are magicians' towers—the highest points of the city—where occult experiments take place. The idea was to present the neighborhood as if seen by a wandering tourist, but at the same time suggest the ethereal but omnipresent power of magic in the city. This is why I chose the point of view of a person in a crowd, but with a very wide-angle view.

The idea was to (suggest the ethereal but omnipresent *magic in the city.*

Illustrations with Photoshop

Stage 1

Sketch and digitization

In traditional art, you almost always start by making a sketch on paper. Photoshop's graphic palette nearly replicates the same feeling. But the fact remains that shaping a drawing on paper is still faster and more intuitive.

The blue creates interesting (halftones that aren't *available with the drawing pencil.*

There is nothing special about the digitizing stage. The image's basic format is 6 x 9 in. (15 x 23 cm.) at 600 dpi, and the final printed image will match the original. I usually work with formats larger than the printed size in order to gain detail and sharpness, as you would in photography. But in this case, increasing the resolution produces a more visible grain in the drawing. Of course, if you want more grain, it might be worth scanning at 1200 dpi to create texture effects similar to a drawing pencil's when seen extremely close up. ■

When creating a series of illustrations it's a good idea to do all the sketches at the same time, then lay them on the floor and look at them as a group, scrutinizing the unity of the work. A computer's screen is too small; just imagine opening nine images onscreen at once.

Even when the basic drawing is done on paper, computer techniques can produce some interesting effects. I do my initial sketch in blue pencil to lay out the shapes, and do a final rendering with drawing pencil. When the drawing is scanned, the blue creates interesting halftones that aren't available with the drawing pencil. In Stage 2 we'll see how interesting those colors can be.

40

05 – The High Terrace

Stage 2

Preparing the layers

Once the drawing is imported into Photoshop, the image must be converted to sepia tones before the color work starts. For that, go to Image→Adjustments→Hue/Saturation, check the Colorize box, and use the sliders to colorize the lines into brown, reddish ochre, or yellow.

This simple method gives a pleasant silkiness to the line, an effect reinforced by the conversion of the original line, which is a mix of blue and drawing pencil. In sepia, the blue yields halftones that are more delicate than if the entire drawing had been done with a drawing pencil. The resulting image is easier to view but retains its basic structure.

Adding color successfully depends on the colors not competing with the lines in the drawing, which they might otherwise weaken. At the same time, you don't want the sketch to overpower the colors. It's a matter of finding the right balance.

I then create two new layers. From the Layers palette, I set the background layer (the sepia drawing) in Multiply mode, and insert it between these two virgin layers. My whole approach is to put colors on what I call the *under layer*, beneath the sepia line drawing layer, and adding detail and finish to the layer above it, in the *over layer*.

The choice of sepia is dictated by technical rather than aesthetic considerations. Brown tones are the result of a mixing of all the colors, so when the picture is colored, the paint colors will blend more easily with the lines. If I had rendered the original line in blue or green, the edges between line and color would be more distinct and less subtle. Using sepia isn't an absolute rule, of course, but it does give the drawing some softness while preserving its descriptive power.

41

ILLUSTRATIONS WITH PHOTOSHOP

Stage 3

The under layers

To avoid getting lost in the details—especially in a picture with so many characters and such elaborate scenery—it helps to choose a dominant color that you can relate all the secondary effects to without losing basic contrast. In this case, the starting point was a fairly dark ochre, which would stand out strongly against the light yellow sky.

Two essential elements had to be brought out: the crowd, which fills the entire bottom of the page; and the open area between the buildings, which leads the eye toward the rocky spires in the distance. The result is a tension between the heavy densities at ground level and the airy feeling of objects above the horizon. I wanted the reader's eye to travel to the characters' faces in the foreground, then look into the distance toward the sky in the center of the image, then come back to the crowd, and so on, impelling the viewer to unconsciously go back and forth. The buildings on the sides of the picture tend to visually limit this movement while giving the picture a narrative element.

Let's come back to the masses of color. After applying the darkest tone on the entire surface with the Paint Bucket tool, you can then immediately add an overall grain to the under layer by going to Filter→Noise→Add Noise. This tool produces a kind of visual vibration that gives the image more surface texture.

However, noise can conflict with the drawing, making it harder to view. To remedy this, I go to Filter→Blur→Gaussian Blur to soften the hardness of the noise (to about 1.0 pixels), which makes the drawing immediately reappear. Even though the noise isn't very visible at the end of this process, it gives you some grain to play with as you build the illustration.

05 — The High Terrace

Stage 3

The next phase consists of placing contrasts in the sky. As with any illustration, you generate a mass of colors by going from the biggest to the smallest objects. Here, that means the sky, then the buildings, the characters' clothes, and finally, the characters themselves.

Material under the sepia layer can be set on several layers and adjusted separately. As you get closer to the final look of the image, you'll refine this or that detail. The important thing is to always work underneath the drawing.

The masses of color are laid down with extremely simple brushes. The approach would have been much simpler in Photoshop 7 or CS, which make handling complex brushes much easier. In the under layers here, the image is filled in with broad brushstrokes of distinct and contrasting masses of color.

You place the color the same way you would with a large-format oil painting. You're

The dynamic of an (image is the hardest thing *to generate on a computer.*

working on an enormous surface, so your movements must be broad and dynamic. In a painting, when you look at a canvas from close up you see a random mosaic of dots, but from a distance, the eye synthesizes the masses and blends the colors. You can do exactly the same thing with a computer. You just need to use enough definition for the broad strokes. ■

ILLUSTRATIONS WITH PHOTOSHOP

Stage 4

The over layer

The over layer is the place where you can adjust, correct, and refine the lines. When it is super-imposed on the under layers, the density of the lines can be pasty and hard to read. The image needs airiness and detailing. This is also the time to lay down the lightest colors, letting the highlights spill over some of the lines of the drawing. This will help smooth out the shapes.

Line — *Over layer*

Under layer + line — *Over layer + line + under layer*

At this stage, most of the effects are manual, and come from pen strokes on the pad. It's impossible to describe them further, since they depend on each person's approach. Photoshop's effects, however, are an aspect of workmanship, of how you approach the image. Consider how the rocky spires climb and disappear into the sky. The way you make them fade is similar to the way we created noise for the under layers, except that you must use a light noise to fade the spires as they reach for the sky.

When the drawing is complete and has been colored, you will often find you are no longer satisfied with the original lines. Some lines may seem too heavy or needlessly repeat colored shapes. You'll need to soften or eliminate the lines that are overloaded with information. For example, the blade on the axe carried by the guard in the middle ground (left image) had too many confusing arabesques. It's better to "quiet" the drawing (right image) by suppressing some details.

05 – The High Terrace

Stage 4

For that, I add a Normal layer and then use the Gradient tool's Radial Gradient style, placing the center of the gradient at the top of the rocky spire. (On the Layers tab, you must set the Gradient tool in Dissolve mode). Once applied, the gradient consists of a cloud of dots that create a noise, which I soften with a Gaussian Blur. You may want to play with the layer's transparency to reduce the effect still further. This yields a more successful result then merging with a simple gradient, which would flatten the surface texture and make the image less warm.

Done in the final stages, these gradients help sharpen the image enormously. They can be applied in various ways—for example, with a dark color starting from the four corners of the image. Darkening the edges of the picture restricts the visual field to the center. For this picture, another option would have been to stress the rocky spire instead of the characters, who would then blend into the scenery, as if they were in the shadow of the buildings.

One thing that is exciting about using computers: even at this stage, you can change an illustration's direction and the ideas it expresses. Of course, you can also do this with traditional art as well, but it's much riskier, after so many hours of work. We rarely set out on a project or a journey with the idea that we'll make our final decision at the end. In the same way, decisions made in these final stages rarely change the thrust of the image in any profound way. ■

45

I used Photoshop to add color to this illustration, but there are other ways to do this, by changing the layers' overlay mode, for example.
It is also possible to do the scratchboard work digitally, using Photoshop, Painter, or Illustrator.

This lets you choose the color of the scratches and modify the image's colored background more easily, but you lose the charm of the imperfections and warmth of traditional art materials.

Studio 06

HIPPOLYTE

Hardware used
- Canson scratchboard
- Conté pens
- PC with 800 MHz Pentium III
- 512 MB RAM
- 30 GB hard disk
- HP ScanJet 5470C scanner
- Wacom Intuos2 A6 graphic tablet

Software used
- Photoshop 7

London Pub

Pencil sketch — *Colors applied*

Final image

For once, this illustration wasn't a commission, just a bit of personal exploration, one of those works that expose you to new possibilities and new artistic and graphic choices. A picture in which you can try things out without fear of rejection.

I felt like creating a fairly dense image that would bring different kinds of characters together in a distorted, arbitrary setting. The atmosphere of a pub suited the mood I was trying to create, and it allowed me to include such diverse characters as aging Sunday sailors, dapper lads strutting their stuff, and of course, the waitress, the barfly's eternal icon. The image wound up being used by my agent, Costume 3 Pièces, to illustrate the agency's year-end presentation portfolio, so my private art project wound up being quite public!

The atmosphere of a (pub suited the mood
I was trying to create.

ILLUSTRATIONS WITH PHOTOSHOP

Stage 1

The Scratchboard

After making a quick pencil sketch, I then turned to the scratchboard. This is a sheet of white paper covered with black India ink that is then scratched with a pen to bring the white out. I used a gray pencil to rough in the drawing on the scratchboard. Once the different elements were in place, I scratched with a pen to reveal the underlying white, and therefore the light.

Scratchboard work is quite demanding, and it requires lot of practice and persistence, because failures are frequent. It's all about light, and you have to define one or several light sources and work only in relationship to them. Remember: as you scratch and crosshatch, the more you scratch, the lighter the piece becomes. That seems simple, but mistakes are fatal and can't be corrected. It's as meditative a technique as you will find.

The main characteristic of scratchboard art is mood, which is often disturbing and mysterious, with characters emerging from the shadows and the surrounding darkness. As with most black-and-white work, however, a successful result means finding the right balance of whites and blacks. What makes working with a scratchboard different is that you must keep some black in reserve, whereas with classical techniques (ink, watercolor, etc.), you tend to save the whites. It's a very different way of thinking about an image. Normally, you add shadow to bring out the sketch of a face, for example, whereas here, you must express your intent by using areas of light.

06 – London Pub

Stage 2

From traditional to digital

Once my scratchboard drawing has been executed in black and white, it's time to add a little color and turn to my old friend, Photoshop. You can add color on a scratchboard in traditional fashion, of course, but you have far fewer choices and nuances.

I first scan the image at 300 dpi grayscale into Photoshop. The image is destined to be printed, so I save it in CMYK mode. My black-and-white image will remain in the background and I will add areas of color on top of it using different layers.

Be careful not to scan the image too dark because you want to retain the imperfections in the black (moirés, fingerprints, etc.) for later on.

I then return to the background layer, pull up the Color palette, and adjust the sliders. This lets me bring out the imperfections I mentioned earlier, which give my drawing a slightly worn, warm look. I especially focus on the part of the image to the left of the waitress, using the sliders to maximize the scratchboard's moiré and intensify the whites. I'll come back here later when I'm ready to make the final adjustments.

To get a general idea of what the final image might look like, I create the first layer in Overlay mode with fairly bright colors to see how my image handles it. For this, I go to Edit→Fill and select Foreground Color from the Use drop-down menu.

ILLUSTRATIONS WITH PHOTOSHOP

Give the smoke a different color so the waitress stands out.

Make the napkin the same color as the shirt.

Add to the contrast by using the sliders to increase the blacks.

06 – London Pub

Stage 3

Adding colors

At this point I start to differentiate the illustration's various elements by adding colors. It's best to color each element on a different layer (a layer for each face, for each item of clothing), so you can freely modify the color nuances and overlay modes throughout the entire process. This is also a way of letting luck play a role, and allowing yourself to be surprised by manipulations you hadn't tried before, which is a large part of Photoshop's charm.

In general, I create layers (set to Hue from the Layers palette) which I paint with a brush at 100% opacity. You can change this later by adjusting the layers' opacity and giving them a more neutral hue. In this case, I painted the cigar smoke with a low-opacity brush to create a slight gradation around the waitress's hair. This makes her hair stand out and gives depth to the background.

It's important to vary the opacity of the paintbrush so you generate a coherent gradation that is neither too rigid nor too noticeable to the naked eye.

Once the main colors are in place, I realize that the image is very saturated. I change the Overlay layer (containing the bright color producing the saturated effect) to a Saturation layer, which brings out the blacks and increases the image's contrast. ■

Once the main (colors **are in place,**
*I realize that the image
is very saturated.*

51

ILLUSTRATIONS WITH PHOTOSHOP

Stage 4

The plaid boxer shorts

All the colors are now in place and the balance is nearly right. But my main character, the waitress, still doesn't stand out enough compared to the pub's patrons. To remedy this, I decide to bring in a small external element for her outfit.

Since a pub setting is involved, there is nothing like a little plaid vest (a graphic element par excellence) to jazz the waitress up. So I grab my favorite plaid boxer shorts and toss them onto the scanner.

I import the image on a new layer and put it above the vest, then draw a quick selection with the Lasso. I invert the selection and erase the excess plaid material.

All that's left to do is to trim away the extra edges and position the remaining piece of fabric under the Saturation layer so it blends with the illustration's range of colors.

By importing a pattern that is different from the rest of the illustration, I enrich my image, add a graphic element (thanks to the squares), hint at the locale, and make my main character stand out compared to the other protagonists. ■

06 — London Pub

Stage 5

Flattening, retouching, and finishing

The illustration is nearly finished. Now comes that all-important stage, flattening the image (Layer→Flatten Image). And here, I get a surprise: my picture has become very dull! So I work on the various color layers to get the result I want.

As a final detail, I add some information about time and place. I put the text in an empty part of the picture, where there's room. It balances the image and gives a nice little graphic touch. Finished!

In the Channels palette I work on the different colors individually and vary the levels. Then I play with those levels on the overall image. Once I'm satisfied, I frame the image to crop out any distracting elements.

53

A path wandering through the woods, the courtyard across the way, the candy store . . . they can all lead to stories. Reality gives photography an endless source of moods and atmospheres. It was in this spirit that I approached this picture showing the first day of a new school year. It was for a children's book, and I wanted to draw on daily life to stimulate my imagination, recreating places that no longer exist except in my memories.

studio 07

JOËL LEGARS

Hardware used
- iBook 700 MHz
- 256 MB RAM
- Canon CanoScan N1240U scanner

Software used
- Photoshop 4

Back to School

Initial setting — *Characters* — *Final image*

This illustration is from a series of picture books for small children published by editions Callicéphale. The focus is the world of school, and specifically, the first day of classes in the fall. Starting with Anne Schwarz-Henrich's text, I hoped to bring to life memories that I still feel very strongly, and in sharing them, help children enjoy the pictures and the story. To create the proper atmosphere, I used a technique that combines painting and photography. How to blend these two artistic techniques wasn't immediately obvious when I started this illustration, but I tried to approach it by combining dream and reality. The method I used is relatively simple and doesn't require sophisticated computer tools. But it draws on intuition and the powerful and creative tools offered by Photoshop.

I hoped to bring to life (memories *that I still feel strongly.*

ILLUSTRATIONS WITH PHOTOSHOP

Stage 1

From text to image

From the very beginning, the text has been my guide—in this case, a nursery rhyme by Anne Schwarz-Henrich. I immersed myself in it, so that my inspiration would be shaped by the story as well as by the music of the words.

For Pataplouf and Pataplon
It's back to school they go.
The courtyard's full of kids they know
All running to and fro.

They laugh to hear Pataplouf say
How cool they found Gris-Nez
How Pataplon got sunburned cheeks
Why he's so blond today.

They're in a line, the classroom's near
Whispers flit from ear to ear.
For Pataplouf and Pataplon
It's the start of a brand new year.

Atmosphere

The angle of the snapshot and the school's architectural style contribute to the general atmosphere. For that reason I photographed the recess yard of what is now a high school in Paris' 12th arrondissement, having first asked permission from the school director. The speed of the film I used—400 ASA in this case—isn't critical. The more sensitive the film, the more grain is visible in the photograph, but modifying the image will erase this grain and produce a more pictorial result, as we will see. Once developed and printed, the photo was scanned into Photoshop. ■

Scouting

I now had to visualize the picture in its entirety, then find a locale that matched my original concept as closely as possible. I usually start by doing a few drawings and then scout out a school building that meets my criteria. I didn't want a place that was so modern that nobody would realize it was a school, or so old that today's children wouldn't recognize it.

I found my starting (image **during** *one of my walks.*

56

Stage 2

Preparation

Ideally, this photograph will serve as my setting, but I want to produce a very clear final illustration, so I need to retouch a few small parts of the image so the eye is not burdened with superfluous details. I create a layer over the background image, and isolate two areas that I want to work on (with the Pen tool) and store them to disk.

The first concerns the sky; a simple gradient will add to the feeling of the end of summer. I use the Brush tool to juxtapose neighboring tones to give the second selection the look I want.

I then select the entire image and apply the Median filter (Filter → Noise → Median) to reduce the picture's overly "photographic" look.

To increase the feeling of depth, I accentuate the outlines (Filter → Sharpen → Unsharp Mask), which makes it look more painterly. This stage is important because I will soon be adding painted characters to the picture.

Mood

I want to give the scene more of a "morning" feeling, by adding a touch of fog. Using the Airbrush on a new layer, I carefully paint some wisps of fog. I use a very light pressure, with the tool set to a sensitivity from 1 to 4%.

ILLUSTRATIONS WITH PHOTOSHOP

Stage 3

Creating the characters

At this point, we are about to fully enter the world of imagination. We are going to move from a setting—a static image—to a crowded recess yard where children are seeing each other for the first time after many weeks of vacation. I started by doing some sketches on loose sheets of paper, to get a sense of each character.

Images of animals are common in children's books because the children can relate to a world with characters like their stuffed animal toys.

Setting

Once I have a sense of what the school children look like, I print a black-and-white copy of the modified photo of the recess yard so I can arrange my characters. I select the draft mode on my printer so it outputs a very pale image. That way, I can sketch on it directly with a pencil.

This is an unorthodox way of working, but it makes my task easier, because it gives me the reference points I need in order to position my figures before making them a final part of the image.

The integration process is difficult, because I must make two totally different worlds coexist without looking artificial. In drawing the characters, I take into account the space available, the elements in the setting (trees, windows, etc.), and the perspective. ■

07 – Back to School

Stage 4

Adding color

To color the characters, I first scan the sketch in CMYK mode (for printing), at a resolution of 300 dpi. I plan to color the images in two stages, using two different methods. The first will involve Photoshop's palette and be applied to the children, birds, and book bags. In the second, I will use acrylics to paint the three characters in the foreground.

Each element is more or less detailed, depending on its distance from the viewer. This gives the image more crispness and clarity. So if I want to stress the bear cub, I make him stand out more. The Unsharp Mask function produces a pictorial effect by overlapping color channels. This produces surprising results, because rendering hides the overly clean look of digital work. I'm not really in full control of the process of creation, any more than a painter controls the accidents that happen along the way, which can produce their share of miracles.

I then print out the sketch—which is still accessible from the background image—on heavier paper that is better suited to acrylic paint. Acrylic dries very quickly and can be painted in layers, unlike gouache, which flakes off. Using water as a thinner, I work in a succession of coats. The overlaps give a sense of volume, and the brushstrokes bring out the textual quality of the medium.

The raw and textured surface of a painting feels more alive.

On this new document, I add a layer and use the Pen to outline the parts to be colored in Photoshop. Each resulting outline corresponds to a selection. For example, let's take the blond bear cub in the middle distance, on the right.

I never use acrylic paints right out of the tube; I always mix them. Acrylics come in a variety of bright colors, and they can be too "electric" if they are used straight.

To finish, I scan and outline the three painted characters in the foreground. ∎

I make a rough outline with the brush.

I then choose a lighter value from the Swatches palette and apply it to the entire character, occasionally overlapping the outlines.

I model the character by adding successively lighter and brighter layers. The trick is to use the Brush while adjusting the tool's pressure, between 1 and 10%.

59

ILLUSTRATIONS WITH PHOTOSHOP

Stage 5

Getting it all together

Now that I have all the elements on hand, it's time to integrate them with the scenery. I use the Move tool to slide them toward the intended image, while referring to my reference sketch. To be on the safe side, I use one layer per character, which will make later individual adjustments easier. When the scene is finally complete I will modify the color mix on this or that detail in order to make the whole coherent; the Curves function makes these adjustments easy.

I therefore enlarge that part of the image, mask the piglet layer, then outline the part of the tree trunk that hides him. I make a selection, bring up the layer again, and eliminate anything that emerges.

At this stage of the process, I step back a bit from my image and think about what parts of it could be improved. After some thought, I decide to add the two birds—the blue one in the tree (below) and the purple one against the right-hand column—to the upper part of the picture, which was a bit lacking in life. This helps make the scene of friends greeting each other fresher and livelier.

The colors chosen for an illustration should match the tastes of its intended viewers. In this case, these are children between 3 and 6 years old, so it's important to use bright colors.

I also make sure that the added elements fit the background correctly. The piglet should be partly hidden by the tree, for example, but I notice that a few porcine parts are sticking out.

07 — Back to School

Stage 6

Depth

To finish up, a few manipulations are needed to make various elements of the image blend naturally into the environment. I approach each character in terms of the courtyard's depth. I want the children in the distance to look fuzzy and less precise, for example, so I use Photoshop's Gaussian Blur. I repeat this for other children, choosing a degree of softness that corresponds to their distance from the foreground.

When using the Airbrush tool, the trick is to work very delicately, again choosing a very light pressure, around 1 to 2%, and adjusting the opacity of the layer if the shadow appears too deep.

For this picture, I used Photoshop the way I would have used paints or colored pencils. The program lets me conceive of something that I wouldn't otherwise be able to render concretely: the marriage of dream and reality. ■

Nature is revealed in its play of light and shadow, and that's what I hope I bring to my paintings.

Shadows

Adding shadows gives shape to the composition while adding realism and a sense of depth. I bring the layers I'm going to work on in front of all the others. An important detail: I set them in Multiply mode from the Layer's palette because I don't want to later find a dark patch that doesn't look right.

In art, you have to find the right balance between too much and not enough. So I sometimes step back to look at the illustration on my computer screen the same way I do when I'm in front of a canvas on my easel. In Photoshop, I progressively reduce the size of the image to get a holistic view of the illustration. I then pretend I'm watching the city change during the hours I spent creating the picture, observing a happy existence captured in one particular place.

studio 08

ANTOINE QUARESMA

Hardware used
- PC with 1GHz Pentium III
- 256 MB RAM
- 20 GB hard disk
- Wacom Intuos2 A5 graphic tablet
- HP ScanJet 4470C scanner
- Zenith digital camera with zoom

Software used
- Photoshop 7

Voyage to Porto

Preparatory sketch — *Applying color* — *Final image*

The image is an (invitation to journeys of yesterday and tomorrow in Porto.

While working on his doctoral thesis on the territorial changes in Portugal in the nineteenth and twentieth centuries, Manuel Nabais Ramos asked me to collaborate with him on an illustrated book about the city of Porto. The aim of the book was to give the history of this "Capital of the North" and to stress the city's economic and cultural dynamism. The author and I also hoped to expose readers to different forms of Portuguese art.

Among the book's illustrations, I'd like to share a striking image from my travel notebook. It shows the fleeting moment when night spreads its palette of colors over the banks of the Duoro, with the golden river gleaming with a thousand reflections of Porto's lights.

ILLUSTRATIONS WITH PHOTOSHOP

Stage 1

Preparatory pencil drawing

I decided that going to Porto for a few days was the best way to capture the very special look of the banks of the Duoro between Porto and Villa Nova de Gaia. I made a trip there in July 2002. I took my time, and in the process, made a few quick studies of the Dom Luis I bridge. While walking through Villa Nova de Gaia—the city on the opposite bank of the Duoro—I found the Serra do Pilar monastery, which has a breathtaking view of Porto and its golden river.

I had carefully visualized the overall layout of the city during my visit, so I used my rough sketches and photographs to create a pencil drawing that showed the area around the bridge as accurately as possible. ▪

I was concerned with faithfully **(reproducing**

the locale, so I took a few photographs to complement my sketches.

I was concerned with faithfully reproducing the locale, so I took a few photographs to complement my sketches. When I got home I adjusted the photos' colors in Photoshop so they would match the ones I anticipated using for my illustration.

Photographs taken from Villa Nova de Gaia

Grayscale scan of the drawing

64

08 – Voyage to Porto

Stage 2

Opening and manipulating the image

Once I had the image in Photoshop, I set its parameters to CMYK. In order to make each line in the drawing distinct, I set the layer involved to Multiply mode. This is the way to go if you want to color a line drawing. The ideal, of course, is a drawing without any shadow or shading, because it's easier to see the different surfaces that comprise it.

Like a painter at his easel, it's wise to proceed methodically when you start coloring an image, laying down successive areas of color that correspond to the scene's various visual elements.

Applying colors

To start with, I select the entire work area. Then, on a layer I name Sky, which is the graphic element in the background, I fill the entire area with sky-blue color. Using the Select→Inverse menu I then paint a coat of earth-tone color on a layer that I call Ground.

The various masses of the scenery.

Working as a (painter would, it's wise to proceed methodically.

I name the layer that corresponds to the drawing in Multiply mode Line. It will remain close at hand in the Layer palette, above all of the layers I will be creating. ∎

65

ILLUSTRATIONS WITH PHOTOSHOP

Stage 3

Lightness, hue, and saturation

At this stage, it's important to harmonize the colors of the river with those of the sky. Before doing that, I add a few clouds to the sky, which I create with the Airbrush tool at 80% opacity and a gamut of colors chosen with the appropriate Color Picker.

For a natural landscape, background colors must be based on a pale, faded blue. Washing out the background relative to the middle ground and foreground makes the image clearer and accentuates the effect of perspective.

I try to find the (chromatic base *using the lightness, hue, and saturation choices.*

Selection with Feather

To work quickly with the different tonalities in an area selected with the Lasso tool, I typically seek the chromatic base using the lightness, hue, and saturation choices option with Feather adjusted to suit the element being treated.

I likewise use the Polygonal Lasso tool to make quick selections on the Ground layer, working on the roofs of the buildings, trying to find the most suitable color, and moving from the background to the foreground. ■

08 – Voyage to Porto

Stage 4

Brushwork brings out the volumes

Painting and drawing, whether with traditional or digital tools, depend on relationships. That is why I never consider part of an image without studying the whole. At this stage I use the Brush at 70% opacity, having adjusted my graphic palette to a very light sensitivity. Again, I work my way from background to foreground by successive touches, giving a feeling of volume to the walls and roofs. I start with the shadowed sides and then continue with the façades that are lit up.

Brush at 70% opacity

As I move toward the foreground I bear in mind that the most varied palette doesn't always produce the most colorful illustration. To the contrary, a sober one often turns out to be the most expressive. To give a sense of unity to the composition, I use the Eyedropper tool to sample colors already laid out in various parts of the picture.

Following the precepts set down by French painter Roger Bissière (1888-1964), who moved from cubism to abstraction, I try not to tackle all the problems at once. Otherwise I would risk losing myself in the subject's complexity.

Checking the clarity of shapes

When I want to check the clarity of the painted shapes and the placement of certain colors with regard to others, I temporarily reduce the Line layer's opacity. ■

67

ILLUSTRATIONS WITH PHOTOSHOP

Stage 5

The Dom Luis I Bridge

This bridge across the Duoro between Villa Nova de Gaia and Porto was designed by Theophile Seyring, a disciple and collaborator of Gustave Eiffel. Inaugurated on October 31, 1886, the 3,000-ton iron structure has an arch 1,450 feet (442 meters) high and two decks, one for pedestrians and one for cars.

Selection by Polygon Lasso tool

The second phase consists of showing the lower part of the bridge with its own, less saturated colors. The bridge has many crisscrossing metal beams, and showing them graphically is tricky, not to mention confusing. That's why I decided to deal with the upper deck separately from the lower one. Putting them on separate layers made it easy to work with a gradient in order to render the areas of light—which contrasted with the darker gradients—from the parts that were in shadow. ■

In selecting the (arch, I use the Pen tool, turn the outline into a selection, then fill the shape with a color suited to the foreground.

In this image, I used two layers to illustrate the bridge. Since the bridge is based on well-defined geometric shapes, for the first layer (the upper part of the bridge), I simply repeat the line drawing original captured with the Polygonal Lasso tool. In selecting the arch, I use the Pen tool, turn the outline into a selection, then fill the shape with a color suited to the foreground.

68

08 – Voyage to Porto

Stage 6

The city lights come on

As with any passion, you have to know when to hold back. So I put off my moment of supreme pleasure, namely, lighting up the city.

For the lights on the bridge's upper deck, I used the Airbrush tool combined with very luminous gradients in Normal mode on the transparent areas of the layer.

The star-shaped bursts of light *are created by a Polygon Lasso selection with a slight Feather.*

The star-shaped bursts of light are created by a Polygonal Lasso selection with a slight Feather. When it's needed, I add a slight Gaussian Blur with a radius of 1.2 pixels, while accounting for the fact that the color of the lights fades with distance and perspective.

For this operation I work with the Airbrush tool in Color Dodge mode at 90% opacity. I start with an orange color, which I intuitively chose from the gamut of colors already present everywhere on the roofs.

It's very tempting to overdo luminous effects, but you must carefully limit the number of light sources. Otherwise you risk disorienting the viewer, whose eye is always first drawn to the brightest part of any picture.

69

ILLUSTRATIONS WITH PHOTOSHOP

Stage 7

The Douro's golden reflections

When you watch the Duoro languorously sliding under the bridges in an eternally repeated pattern, the river seems loaded with gold-bearing alluvium. Maybe that's why it glitters so brightly when the sun comes out from behind the clouds.

The Airbrush tool

To convincingly render these wave-like jewels, the Airbrush tool at reduced opacity and in Color Dodge mode are perfect. Combined with the extreme flexibility of the graphic palette pen, it gives the waters a feeling of voluptuousness that is almost palpable.

With the foreground reflections, I create a selection with a Feather radius at 40 pixels and apply a Ripple filter of Medium size to make the chosen element stand out.

To create the reflections, it might have been simpler to copy the layer on which the lights were located, rotate it 180 degrees, diminish its opacity, and play with the different layer modes. This makes use of Photoshop's many possibilities and would probably have saved a great deal of time. But I preferred to make the pleasure last. So I used the Airbrush instead, carefully placing each light's reflection in the water while remaining true to the perspective of the scene.

In some areas of reflections I apply a slight horizontal blur, to suggest the horizontal movement of water. ■

Directional Blur, horizontal direction

08 – Voyage to Porto

Stage 8

The Boats

In the illustration, pleasure craft and small fishing boats are moored among the distinctive *rabelos,* which were once used to carry Porto wine. Today, the wine industry uses faster and more efficient shipping methods, and those boats are just part of the scenery. But the little port of Ribeira would lose its soul without their presence. I couldn't very well portray Porto and its main activity without showing the boats.

These parts of the scenery are in the middle distance, so it wasn't important to render them in too much detail. Having outlined selections on the Line layer, I tried to blend the various hull colors into their immediate environment.

Having outlined (selections on the Line layer, *I tried to blend the various hull colors into their immediate environment.*

On the Water layer I then used the Lasso tool to outline the shape of the shadows on the water and drew them in freehand, taking perspective into account. I then chose the lightness and the hue of the shadow using the keyboard shortcut Ctrl-U. And that's it—the drawing is finished! ■

Outlining the shape of the shadows

As soon as you start thinking about a picture, make it a pretext for a new challenge or a joyous experiment, even if creating an illustration can be laborious and the source of torment and self-doubt. If you want to produce something different or renew yourself personally, you must go beyond your habits and influences. Drawing is both a passion and an everyday job. Sometimes it merely consists in raising your eyes and looking at people in the street a little more carefully—which may be the part I like best.

studio 09

MARGUERITE SAUVAGE

By the Swimming Pool

Hardware used
- PC
- 256 MB RAM
- Two hard disks (15 and 30 GB)
- Wacom Intuos2 A5 graphic tablet
- Iiyama 19-inch monitor
- Col-Erase and soft art pencils

Software used
- Photoshop 6

The setting | Colors

Final image

With its characters and setting, I think this illustration is very representative of my style. I tried a number of different techniques and ways of approaching the topic—experiments that I use to this very day. It was created for the summer 2002 edition of TGV Magazine, which is published by the Textuel agency for SNCF, the French national railroad. This upscale monthly, sent free to TGV passengers in France, is a lifestyle magazine with in-depth articles, not just a handout designed to promote SNCF and its partners.

I enjoyed working in this medium because the creative process is fairly unusual, midway between advertising and journalism. I am more accustomed to creating artwork for children—in books or magazines—or for a female readership. With this publication, I could dive into creating a world around my characters, while coming up with little details of decoration or attitude.

With this kind of publication you are (free to suggest *almost anything, and you're rarely asked to make many changes.*

Stage 1

The assignment

The illustration ran as the opening art for the magazine's regional edition. Its large format (6.9 x 7.3 in.) allowed me to spend time on details, and the image wasn't compromised by having text above or below it.

The art director wanted a mood that was "very summery, light, and fresh." She initially suggested showing a nearly empty city of lawns and parks, in sunny weather, with cats in sunglasses lounging on terraces and rooftops. I didn't pick up on her idea because it had no men or women in it, and I really enjoy drawing people. But the art director was open to other suggestions, so I sent her a rough sketch of a couple standing on a terrace in front of a seaside town.

A kind of perceptual drift, an accumulation of interpretations, occurs between an initial assignment and the final rendering. Usually this is a plus, but you have to get along well with the people making the assignment, and not lose sight of the project, even in the rush of creativity. Otherwise you wind up having to make a lot of changes and the final image will often be impersonal. It's essential to formulate your ideas and stick to your point of view. This can be a difficult balance to attain, and much depends on the actors in the creative process.

The roughs

In my first rough the image was too urban and the terrace too enclosed; it didn't make you feel like sunbathing or diving into the ocean. On a second rough, which had more of a Latin feel, I had a lover serenading a bathing beauty.

09 – By the Swimming Pool

Stage 1

I then eliminated the cat and replaced the guitar player with a more serious, active man who was closer to the magazine's target readers. That rough showed the bathing beauty and a golfer, a character who struck me as the embodiment of summertime leisure. I worked on the faces with special care, giving the man a broad smile and the woman a haughty look.

An article about golf that had been planned for the issue fell through, so I had to rework the male character. I suggested a tennis player, and went ahead and inked and colored the picture. I got a little carried away: I dressed him in shorts before it occurred to me to switch to long pants, in keeping with his chic and elegant look.

I draw my roughs in blue, using the kind of Col-Erase pencil often used by animators. It's a habit I picked up when I was drawing comic books and working on video games, and I kept it because I like the surface texture it produces. When I submit a rough, I first scan my pencil sketches, then quickly clean them up with a white paintbrush while increasing the brightness and contrast. I sometimes use Photoshop to add decorative elements, using presets or drawing with the graphic palette, when they aren't already sketched. I also occasionally add gray shadows in order to emphasize certain depths or volumes.

In general, I scan in grayscale, which is quicker. (It isn't necessary to submit the blue rough.) When changes are requested, I often have to show the elements in pieces: a character on one sheet, an object on another, a leg somewhere else—a real jigsaw puzzle. To do that, I put each element on a layer in Multiply mode and adjust the sizes in Photoshop so they all fit together.

Before graphic artists started working digitally, a change usually meant a lot of extra work. But I wonder if digital technology hasn't made changes routine, since they are supposedly easier to make. ∎

75

ILLUSTRATIONS WITH PHOTOSHOP

Stage 2

The line

Once my overall rough is approved, I either ink the blue pencil sketch directly or print out the scanned image (still in blue) with all the elements in place. I do my inking with a drawing pencil or a soft black pencil to retain the feeling of a rendering. It's important to me that there should always be some feeling of traditional drawing in my images. In fact, the more I work, the more I'm committed to drawing in the classical sense. For that reason, each picture is an arena for experimentation. People very often mistake my drawings for vector-based renderings, and it's true that they tend to look more like images created with Illustrator. But in fact my illustrations are created entirely in pixels from material made in or imported into Photoshop.

When I have inked in the pencil drawing, I rescan it and clean up my sketch with Photoshop's Brightness/Contrast option to clearly differentiate the blue of my inked line. I then use Select▶Color Range eyedroppers to select the blues and make them disappear while strengthening the grays and blacks.

How do I retain a traditional "drawing" quality in my picture, while producing a modern graphic based on color washes and patterns, but without lines? When my pictures don't pan out, it's often because of an imbalance between those two imperatives. This also explains why an image that appears simple at first glance can sometimes be laborious to produce.

09 – By the Swimming Pool

Stage 2

Most of the time I keep the layer with the rough below my final image. It serves as an anchor for elements of the scene or for objects whose outline I will ultimately erase.

In some ways this layer is the underpinning of the drawing. I move my layer of inked elements in Multiply mode to the top of the pile of layers. The elements are more or less organized by colors, opacities, and shapes, but the arrangement of layers is often pretty chaotic by the time the picture is finished. I am self-taught and I sometimes make life hard for myself with jury-rig techniques. There must be simpler ways to get the same result.

Once the overall color is done, I turn the black lines into colors, erase them, or adjust their density. This is a method I learned recently, again by browsing through a book on poster artists and the work of René Gruau, whom I admire. ■

I discovered the (applied arts through such *poster artists as René Gruau.*

ILLUSTRATIONS WITH PHOTOSHOP

Stage 3
Color and details

In choosing the colors of the villa with its swimming pool, I drew on Saint-Tropez for inspiration. I had taken some photographs and sketches during a quick visit to the town, so I used them to create a sort of caricature of the people. I thought that pure white was perfect for the clothes and the house. To start with, I roughly defined the colored areas of the characters to get a good sense of the color balance and the emphasis of the image's composition.

Like color, details are essential to the mood of an illustration. The cocktail, the deck chairs, the boats in the distance, the palm trees, and the diving board are all elements which at first glance don't seem essential but which all help to define the mood of the image, to make it palpable and therefore pleasant to look at.

The woman's oversized sun hat suggests chic, excess, allure, and seduction, while her suggestive pose expresses laziness, vacations, and summer. I added to that feeling with the detail of the fruit cocktail and the deck chairs in the background as a warm invitation to join the characters. In addition to style, tennis suggests a concern for health and staying in shape. The shadows under the characters make them stand out, give the image some relief, and help underline the composition. The woman frames the right side of the drawing and invites the reader's eye to linger on her.

I chose the warm blues and oranges that had appealed to me during my first year of work as an illustrator. I like the balance of these colors and the pleasant feelings they generate. They're also completely appropriate to this drawing. The background is grayer and colder on purpose. This matches the somewhat foggy look of a seaside landscape, but the choice of neutral colors also helps avoid the risk of overwhelming the main scene.

09 – By the Swimming Pool

Stage 3

I work almost entirely in flat coats of color, using very few gradations on the people and almost no filters. To select areas of color, I use the Polygonal Lasso tool (I like its angular aspect). I then work on those areas with the Brush in terms of their volume and their lighting, or I define angles of gradation in terms of the light on the objects and the setting.

I create many layers, by color and by element.

Coloring the image this way takes more time than simply filling it in, but it allows me to accentuate certain shapes. I don't try to render lights and volumes realistically. That wouldn't suit my style of drawing or my kind of illustration. My main goal—and I do my best to attain it—is that my drawings come together and be engaging.

This illustration has a "chic 1970s vacation resort" feeling—a retro cliché that echoes a current fashion trend and fits the assignment very nicely. Since finishing this image I have tried other experiments, and new influences have enriched and improved my drawing style. I always try to make light, cartoon-like, optimistic images that can influence daily life in a positive way—and I hope that's what I've achieved here. ■

What I bring to (**each drawing**
is not a "scientific" technique.

the authors

BENGAL
Graphic novel designer, artist

A self-taught artist, Bengal first showed his work to graphic novel publishers in 1998. While completing an initial book with éditions Glénat, he took a job as a designer with a video game development studio. He is now working on more graphic novels and recently published *Meka* with Delcourt.

bengal@cafesale.net
www.cafesale.net

NICOLAS BOUVIER
Video game artist, art director

Nicolas Bouvier has been working in the videogame industry since 1996, first as lead artist, then as an artistic director for Darkworks, a French studio formed in 1997. He worked on several French game projects before becoming lead artist on *Alone in the Dark 4*, a major sequel to the well-known Infograme trilogy (1992–94). He also contributed to the other Darkworks projects, collaborating with such companies as Capcom and Namco. In late 2003, Bouvier moved to Montreal to work at Ubisoft Entertainment. He is currently an illustrator-designer for the next *Prince of Persia* sequel. In his spare time, he creates book covers for such publishers as Gallimard and Fleuve Noir.

nbouvier@ubisoft.qc.ca
www.sparth.com

BENJAMIN CARRÉ
Book illustrator, game designer

With a brand-new 1997 diploma from the French graphic arts school ESAG, Benjamin Carré made his debut as an illustrator on *Néphilim*, a role-playing game published by Multism. In 1998 he created his first science-fiction book covers for J'ai Lu, then worked with Denoël in 1999 and Gallimard in 2001. At the same time, Carré became a video game designer with Darkworks for *Alone in the Dark 4*. He has continued with all these activities (plus a few others: posters, CD jackets, graphic novels), while mainly working on covers for novels and on video games.

www.blancfonce.com

JUDITH DARMONT
Painter

If Judith Darmont has any artistic ancestors, they are Art Deco painter Tamara Lempicka (1898–1980) and one Macintosh computer inventor. A classical and digital painter, Darmont starts with a scene from everyday life, adds some patterns and bright colors, and winds up hinting at unusual stories. She first used a computer in 1989, after studying design in Lyon and spending two years in Jerusalem creating sets for television. A decade of exploration followed, in which she learned new technologies, tried multimedia writing, drew advertising art, created CD-ROMs, and designed for TV shows and web sites.

NICOLAS FRUCTUS
Graphic novel artist

Having worked as an illustrator since 1991, Nicolas Fructus takes graphic art projects as they come along, alternating between cartoons, illustration, and advertising. He spent four years as art director with Arxel Tribe, developing graphic interfaces for video games (*Pilgrim, Ring, Faust*). He went independent in 2000, and has mainly worked on the *Thorinth* graphic novel series for Humanoïdes Associés, while also branching out into fantasy illustration, posters, and film.

www.humano.com

HIPPOLYTE
Freelance illustrator

Born in 1976 in Haute-Savoie, Hippolyte lives in Clermont-Ferrand and contributes to newspapers, magazines, books, and advertising (*le Monde, le Nouvel Observateur, le Nouvel Hebdo, TGV Magazine, le Monde informatique,* éditions Nathan, éditions Glénat, éditions Alain Beaulet). He is the author of *Dracula*, published in France by Glénat, and in the U.S. by Dark Horse.

hippolyte@hippolyteartwork.com
www.hippolyteartwork.com

THE AUTHORS

JOËL LEGARS
Freelance illustrator

Joël Legars first published his drawings in éditions Hachette's Poche jeunesse collection. He then contributed to several journals for children and worked on extracurricular publications, notably for éditions Nathan. For the last few years, he has been creating children's books (éditions Callicéphale, Hemma) while working as an illustrator for publications for adults *(Soins, Ortho magazine, Valeurs mutualistes, l'Info Métropole)*. He is currently working on a comic book.

joellegars@tele2.fr
www.coconino-world.com

ANTOINE QUARESMA
Layout artist, computer graphics designer, colorist

After studying at the Académie des beaux-arts de Brive and the Centre national de la bande dessinée et de l'image (CNBDI) in Angoulême, Antoine Quaresma spent eight years as a middle-school lecturer in plastic arts. In 1998 he joined Studio Cartoon Express as a layout artist, computer graphics designer, and colorist on the 26-episode cartoon *Tristan et Iseult,* a France 3/Canal+ co-production. In 2000 and 2001 he was a computer graphics designer for Studio TTK, working with local Angoulême graphic specialists on the *Cartouche* cartoon series broadcast by M6 and Télétoon. In addition to illustrating *Porto, Invitation aux voyages d'hier et de demain,* by Manuel Nabais Ramos, Quaresma has worked on *Histoire d'un merle blanc* (Saintmont, 2003) and *L'armée des anges* (Humanoïdes Associés, 2003 and 2004).

antoine.quaresma@wanadoo.fr
perso.wanadoo.fr/antoine.quaresma

MARGUERITE SAUVAGE
Illustrator

After graduating with a degree in communication in 2001, Marguerite Sauvage decided to devote herself to her passion: illustration. A self-taught artist, she has freelanced for newspapers and magazines, book publishers, design consultancies, and ad agencies. Her drawings have appeared in the United States, Europe, and Japan for *Elle, Cosmopolitan, Glow,* and others. Sauvage is interested in every kind of subject and medium, from the Internet to books to audiovisual. She has also done animated advertising for Galeries Lafayette Service and product design work for the luxury St Dupont brand.

margueritesauvage@wanadoo.fr
http://www.margueritesauvage.com

THE TRANSLATOR

WILLIAM RODARMOR
Translator, journalist, book editor

William Rodarmor is a French literary translator with a background in computers, law, and sailing. Of his 15 translated books, *Tamata and the Alliance,* by Bernard Moitessier, won the 1996 Lewis Galantière Prize from the American Translators Association. Rodarmor translated *Creating Photomontages with Photoshop,* also part of O'Reilly's "A Designer's Notebook" series. A freelance book editor with a special fondness for European graphic novels, he lives in Berkeley, California.

rodarmor222@aol.com
www.editorsforum.org

gallery

BENGAL

BENJAMIN **CARRÉ**

NICOLAS **FRUCTUS**

MARGUERITE **SAUVAGE**

Robot Lady

BENGAL

When I lay down the first suggestions of color, I haven't settled on a final palette—I'm just trying a few broad brushstrokes on the surface.

After roughing in the main tones, darkening the background helps isolate the center of the scene. I add light or shadow on extra layers that I can eliminate if I decide some details are superfluous.

This image is typical of my little world, and yet at the same time it is very specific, which is what makes it so distinctive.

Blanche

BENJAMIN CARRÉ

I had originally planned to show a city with tall buildings that reinforced a feeling of strong verticality.

Blanche

Yet this photograph stresses the horizontal, in a format that is itself horizontal. I better be sure to find that verticality somewhere else.

ILLUSTRATIONS WITH PHOTOSHOP

While the quality of an illustration's composition is the key to its success, the little details shouldn't be overlooked. They make a picture more believable, more real.

I make the main structure a little dirtier, cut out the windows and paste in sections from a photo of a glass building shot at sunset, and replace a background wall with a façade from another photo.

The big buildings in the background also need façades. Here I select a tiny piece of a façade, then copy and paste it repeatedly to create the surface I need.

I take the Airbrush and draw the little vampire standing on his cable.

The High Terrace

NICOLAS FRUCTUS

The High Terrace

Noise can conflict with the drawing, making it harder to view. To remedy this, I soften the hardness of the noise to about 1.0 pixels. Even though the noise isn't very visible at the end of this process, it gives you some grain to play with as you build the illustration.

ILLUSTRATIONS WITH PHOTOSHOP

Two essential elements had to be brought out: the crowd, which fills the entire bottom of the page; and the open area between the buildings, which leads the eye toward the rocky peaks in the distance. The result is a tension between the heavy densities at ground level and the airy feeling of objects above the horizon.

One thing that is exciting about using computers: even at this stage, you can change an illustration's direction and the ideas it expresses. We rarely set out on a project or a journey with the idea that we'll make our final decision at the end.

By the Swimming Pool

MARGUERITE SAUVAGE

A kind of perceptual drift, an accumulation of interpretations, occurs between an initial assignment and the final rendering. Usually this is a plus, but you have to not lose sight of the project. It's essential to formulate your ideas and stick to your point of view. This can be a difficult balance to attain.